Scratch your Creative Itch

To begin, select a page to draw on, then remove the stylus from the case. Follow the illustrated designs on the left as inspiration to begin your drawings, or if you prefer, work freehand to make your own creations. Use the tapered end to scratch larger areas and the pointed end for details to further embellish the page by revealing parts of the colorful background. Tear out the page along the perforations to work outside of the book, or when you are ready to display your scratch art.